SIZZLE
PRESS

T0019353

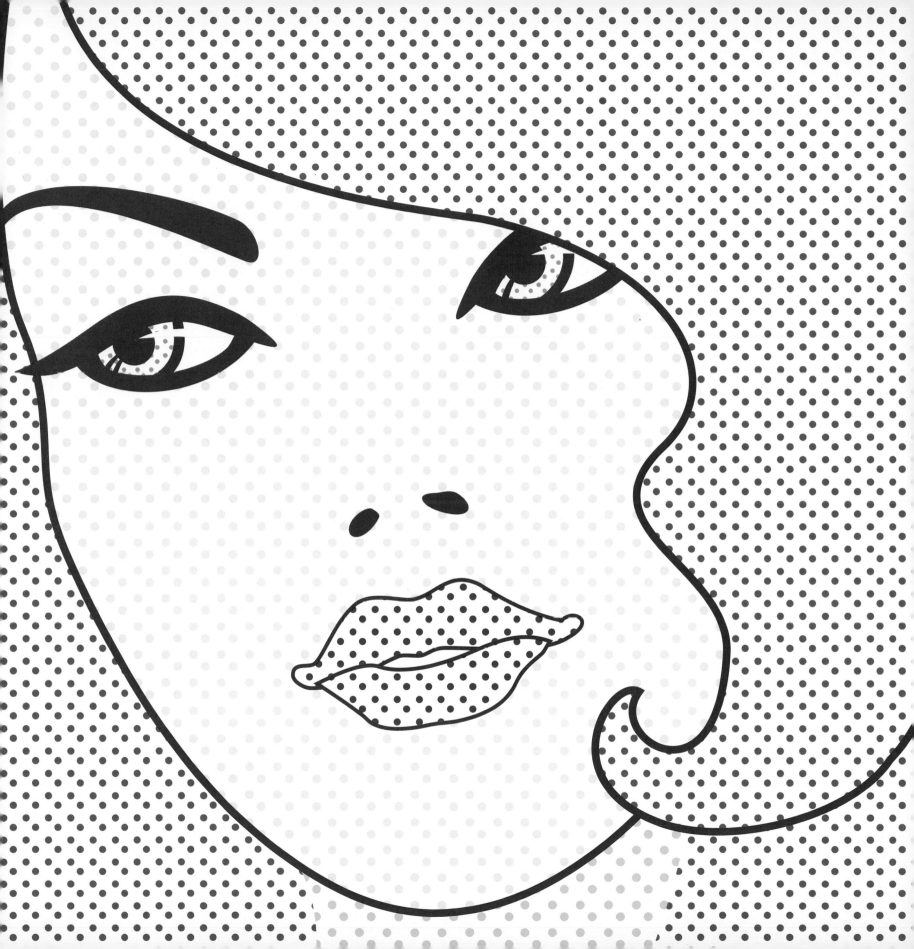

PUCKER UP, DARLING, AND COLOR ME PRETTY!

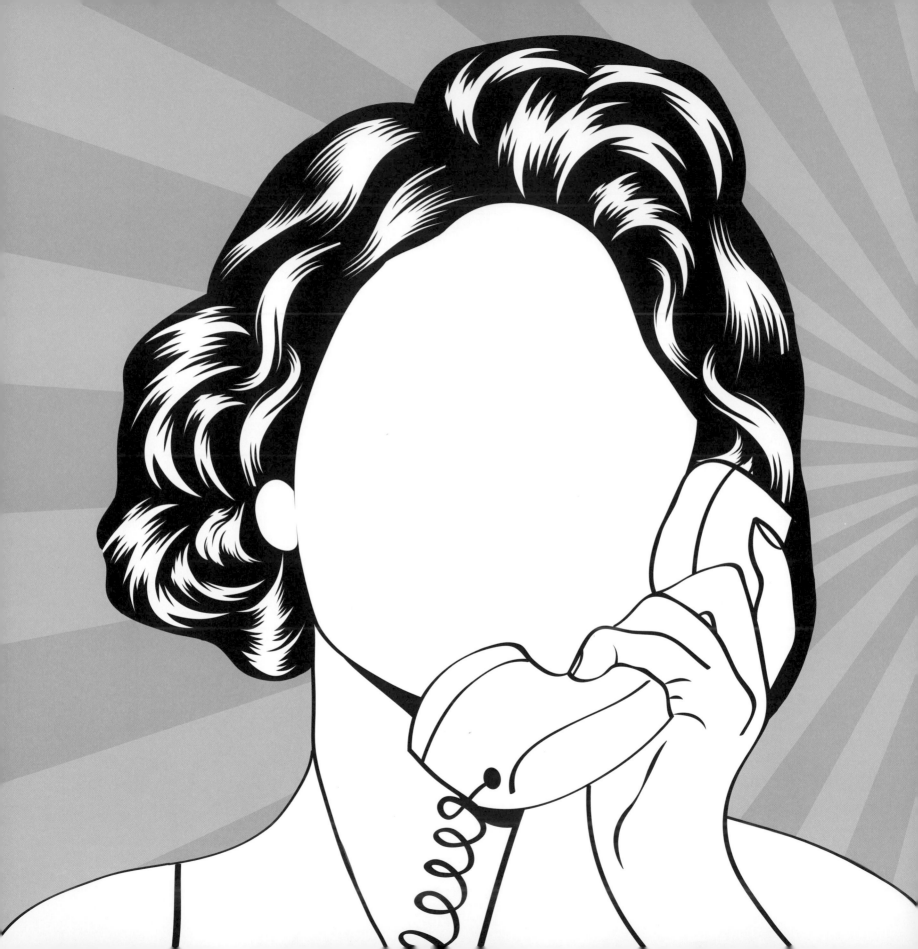

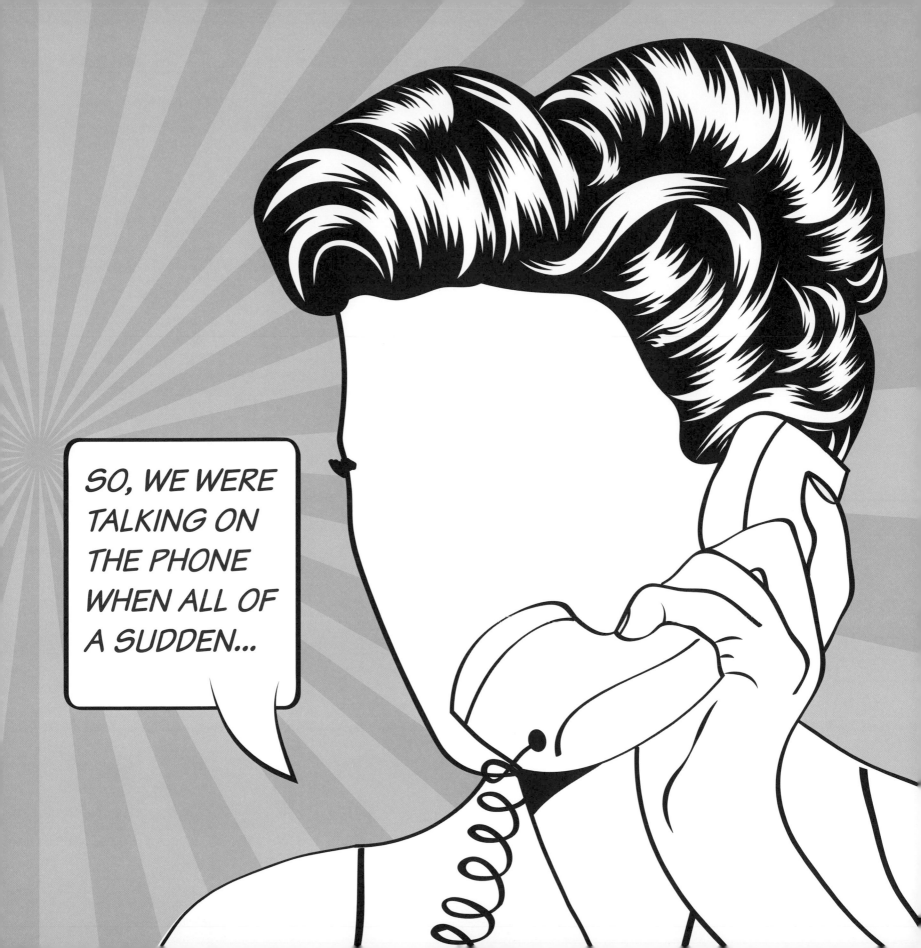

CALL ME!
COLOR ME!

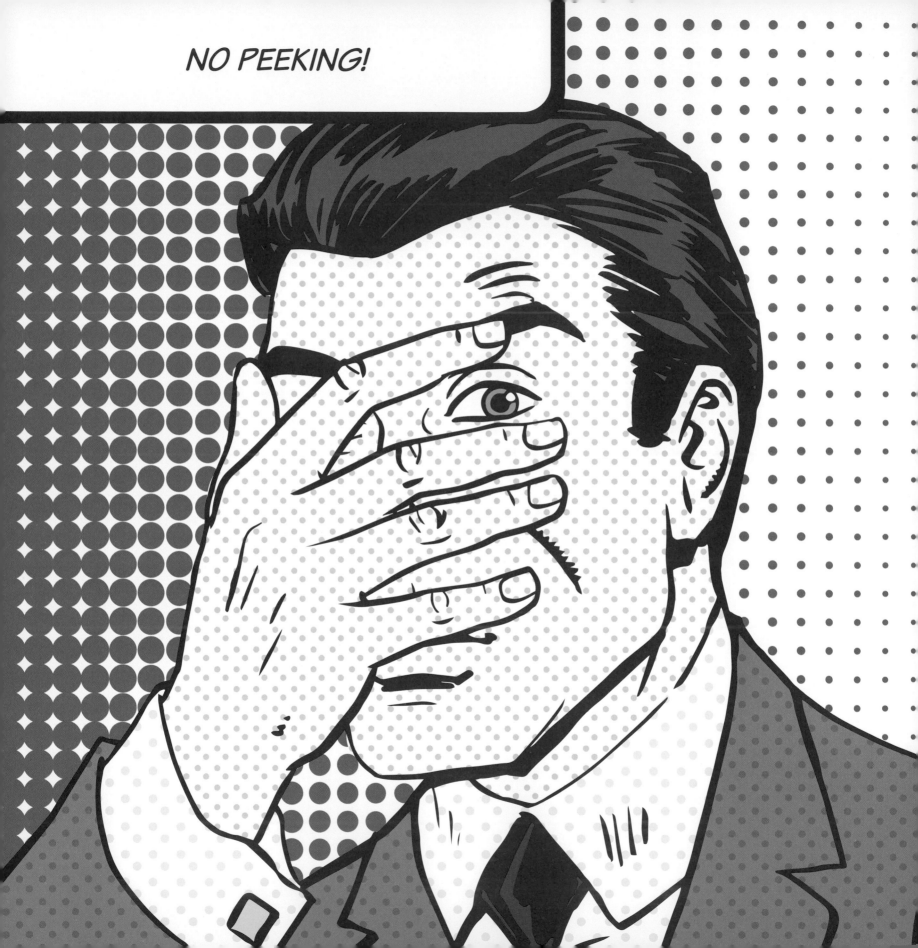

MOVIE NIGHT!

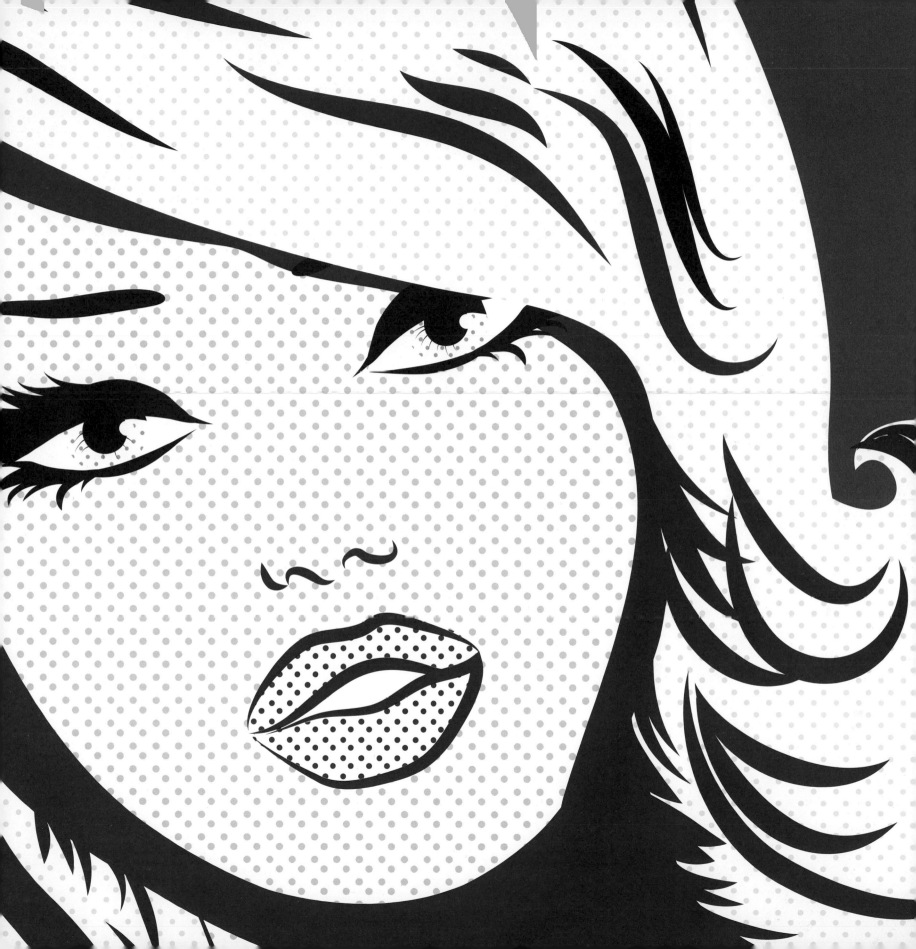

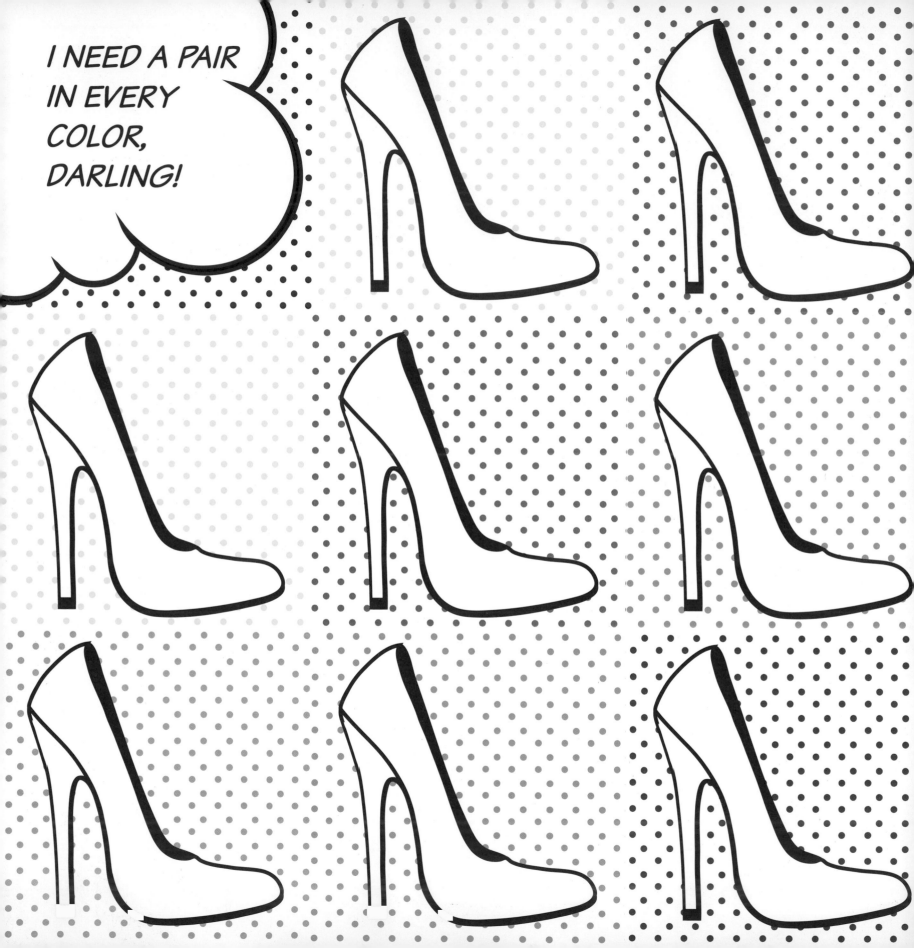

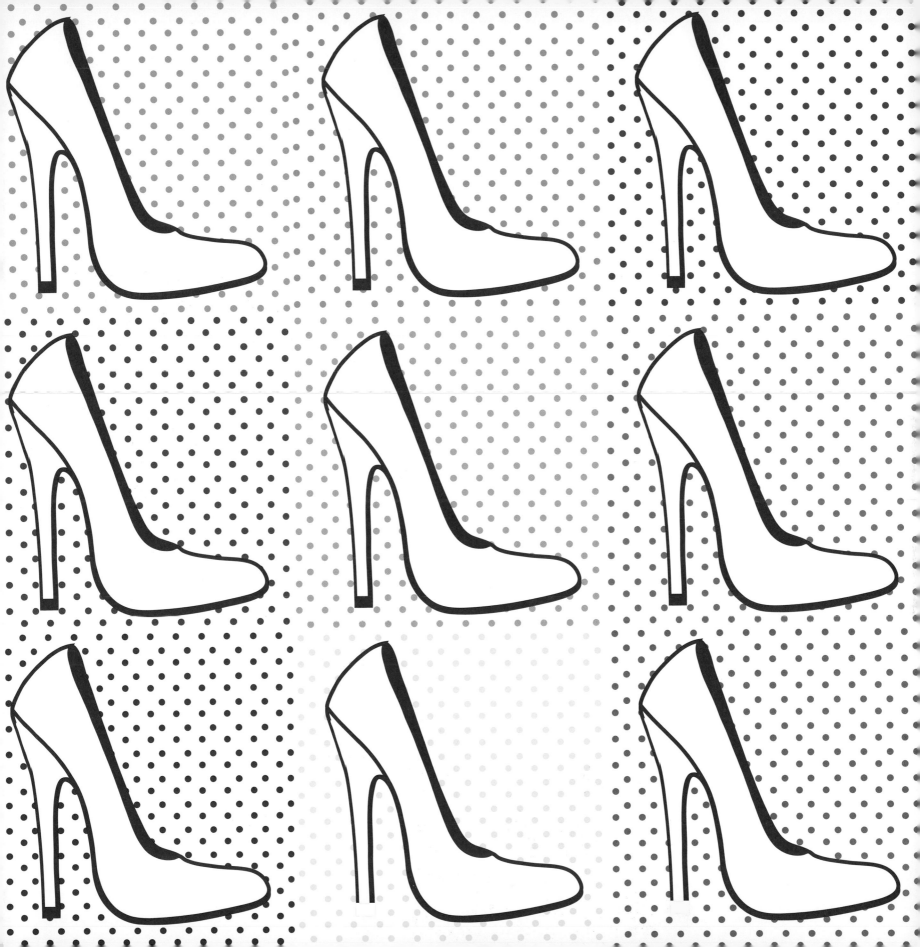

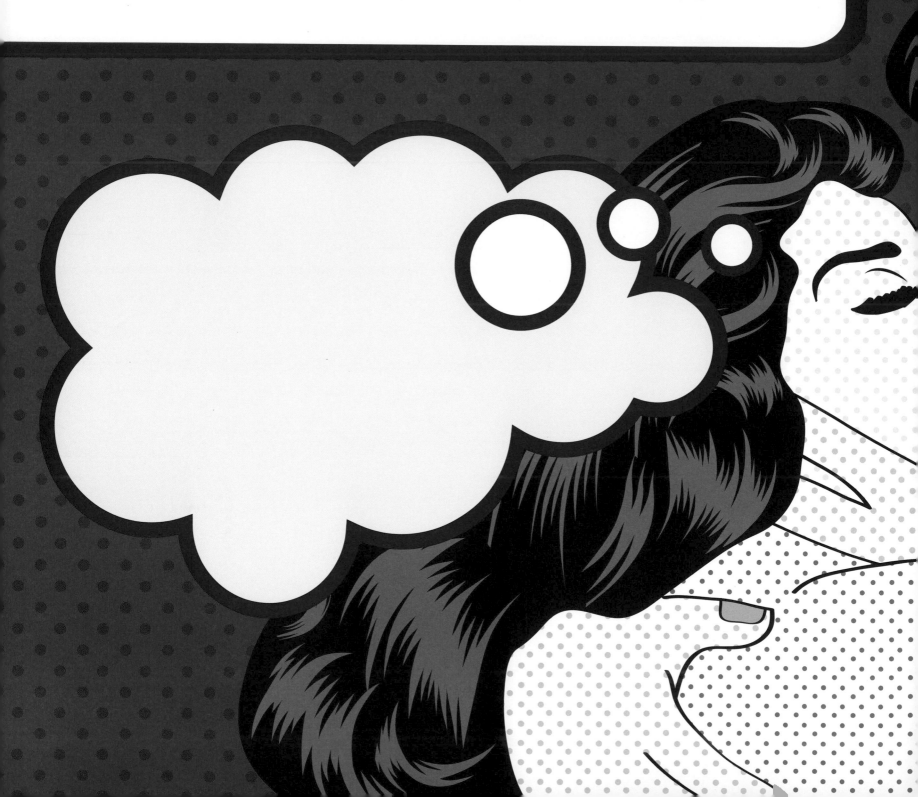

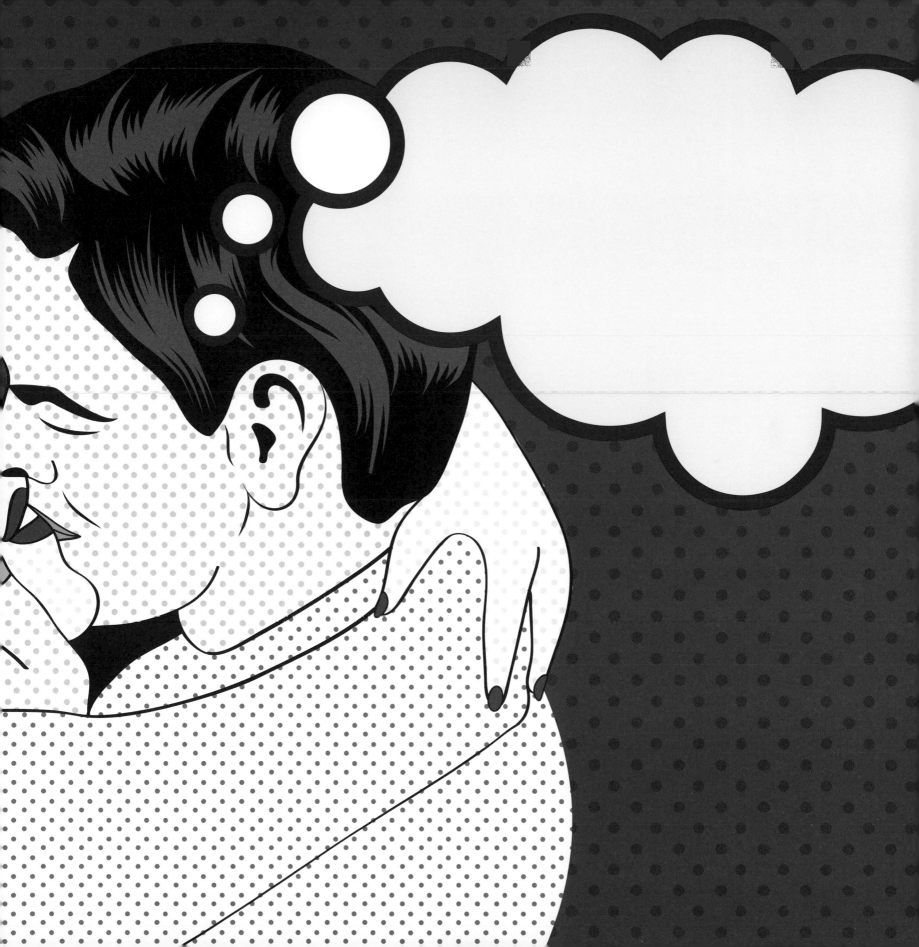

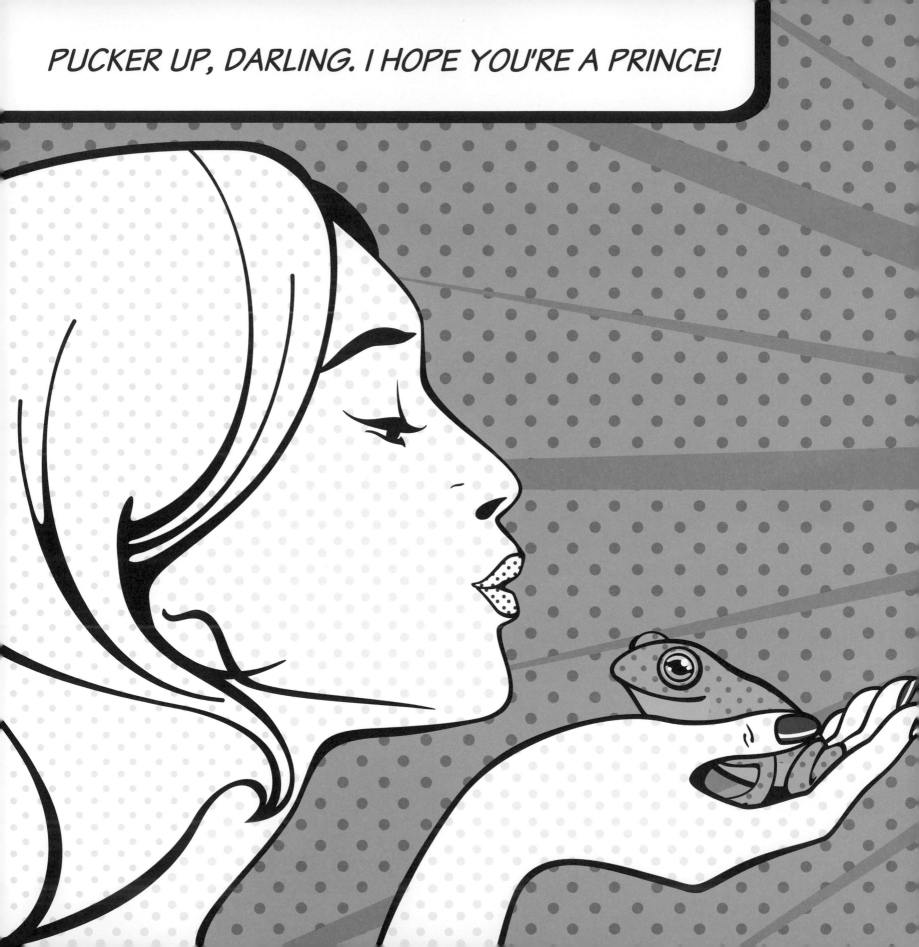

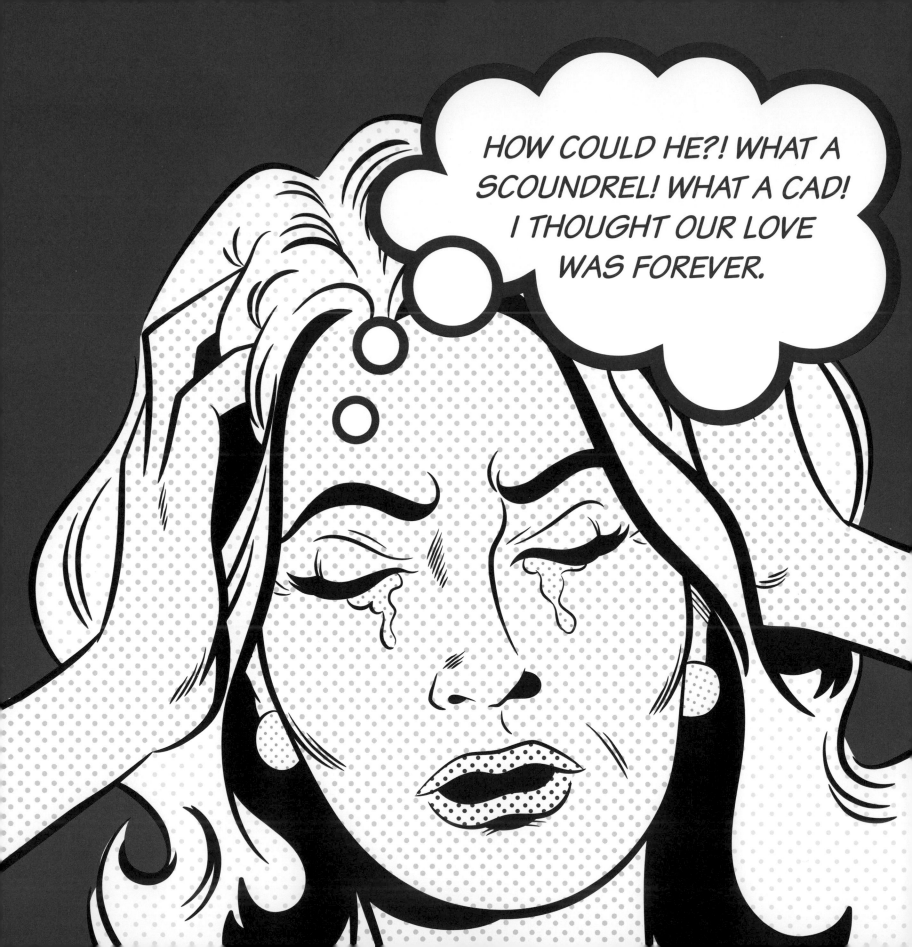

COMPLETE THIS
RETRO HONEY'S
PERFECTLY HIP
THREADS.

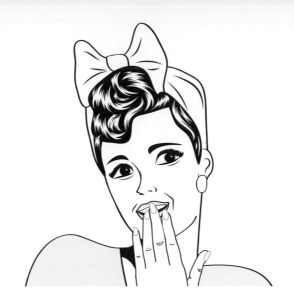

STYLE THE DOLL FOR THESE LIPS.

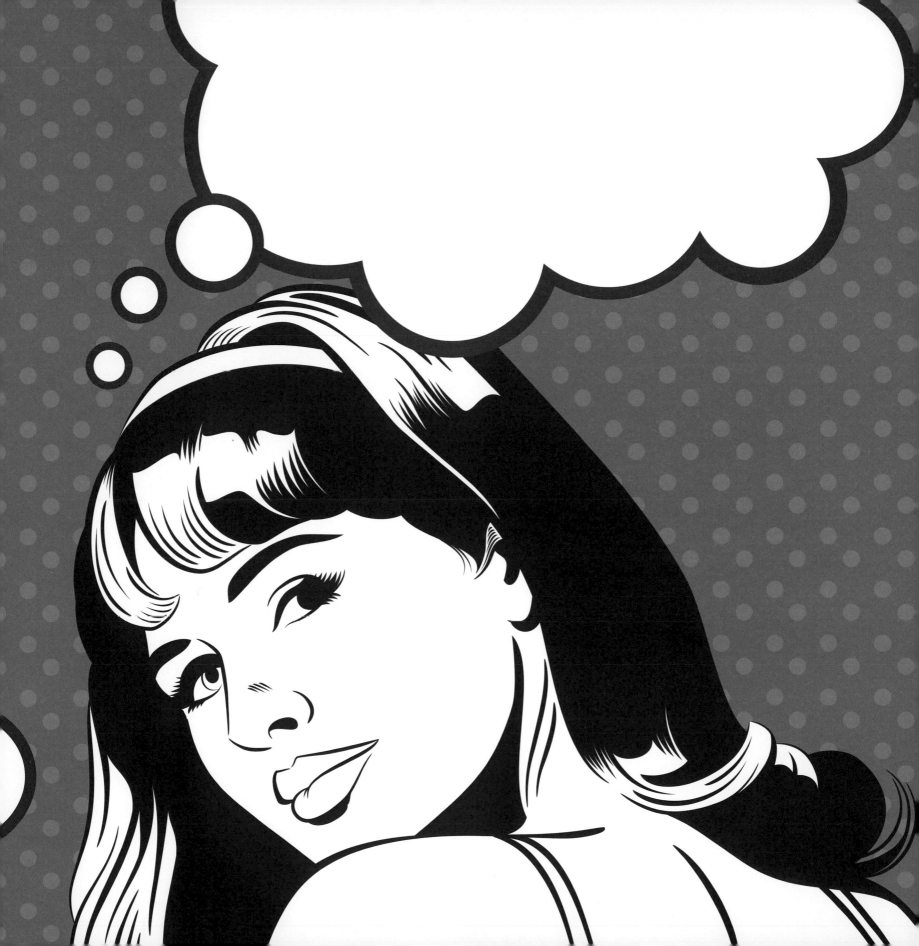

HEAVENS ABOVE! WHAT IS THIS GAL EYEBALLING?

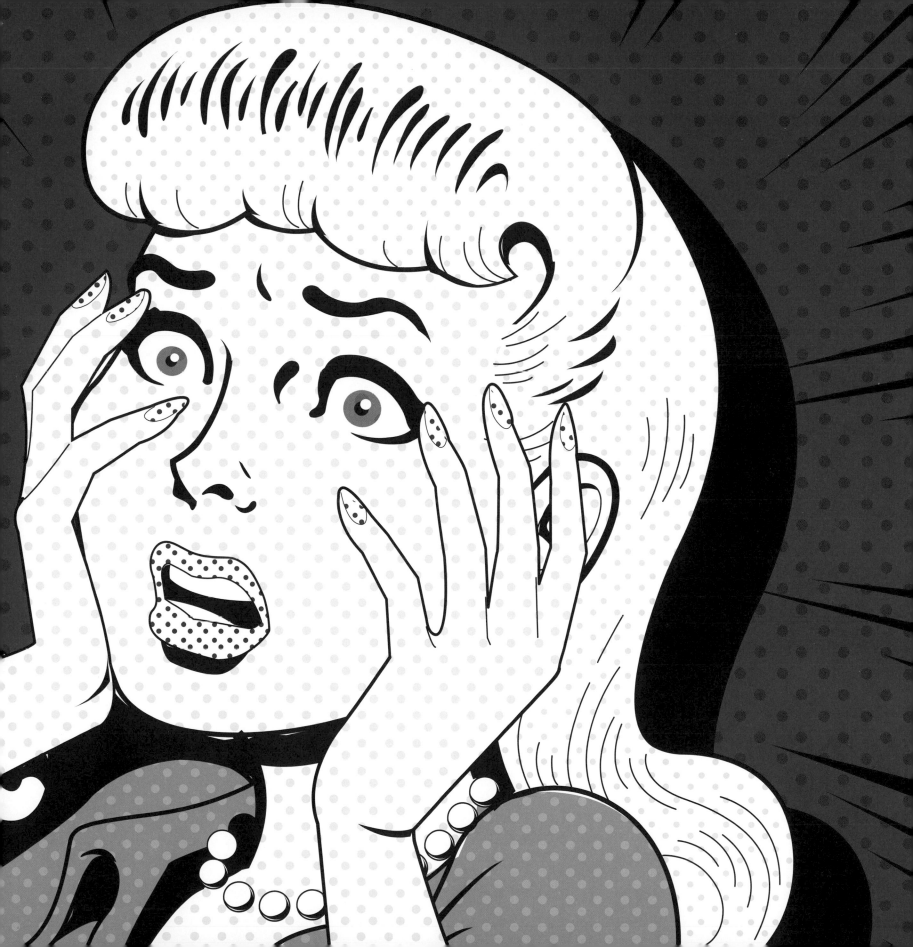

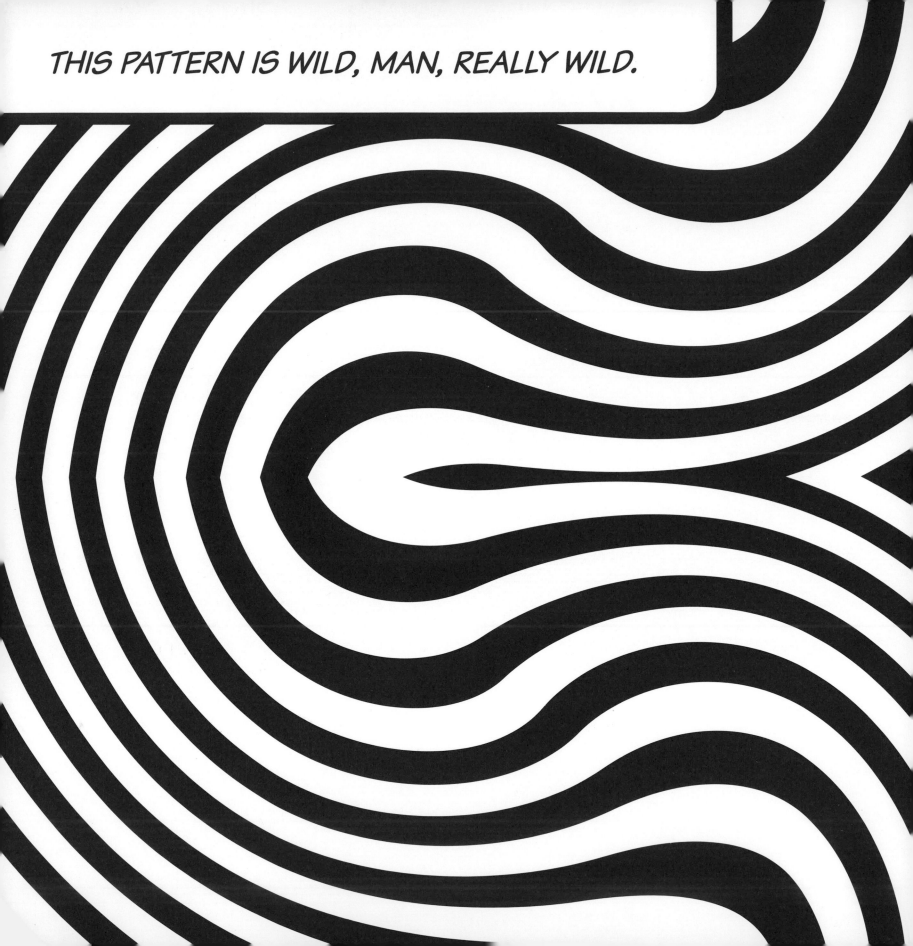

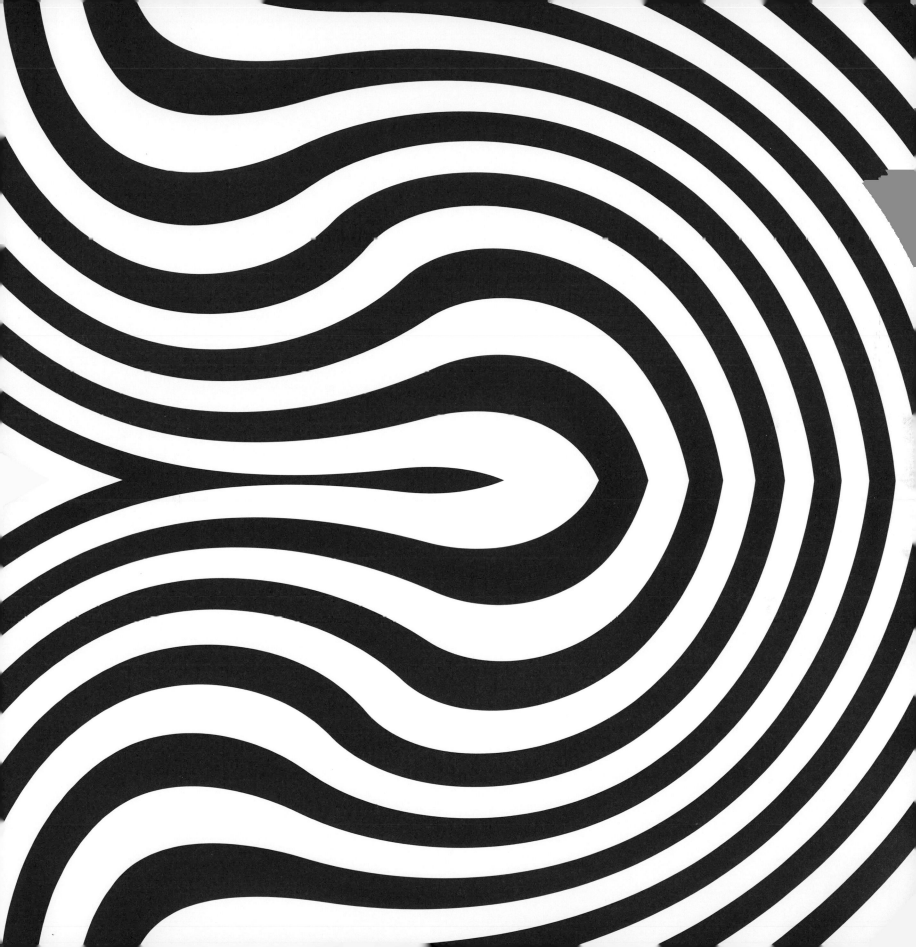

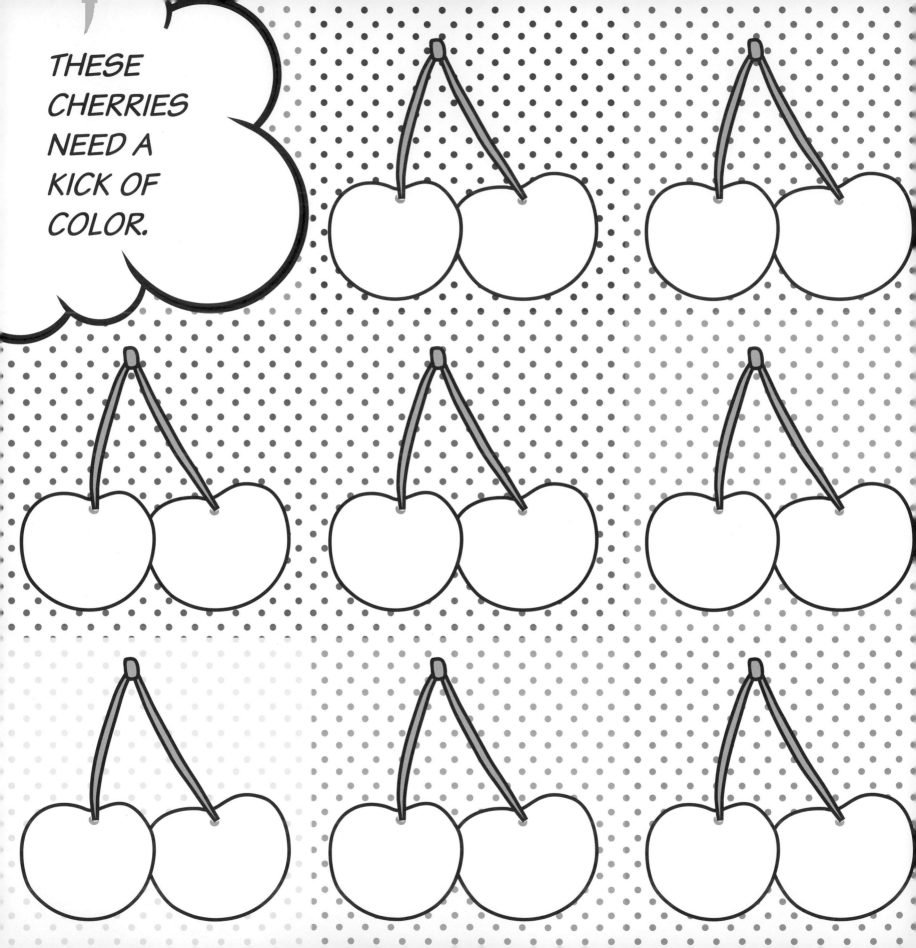

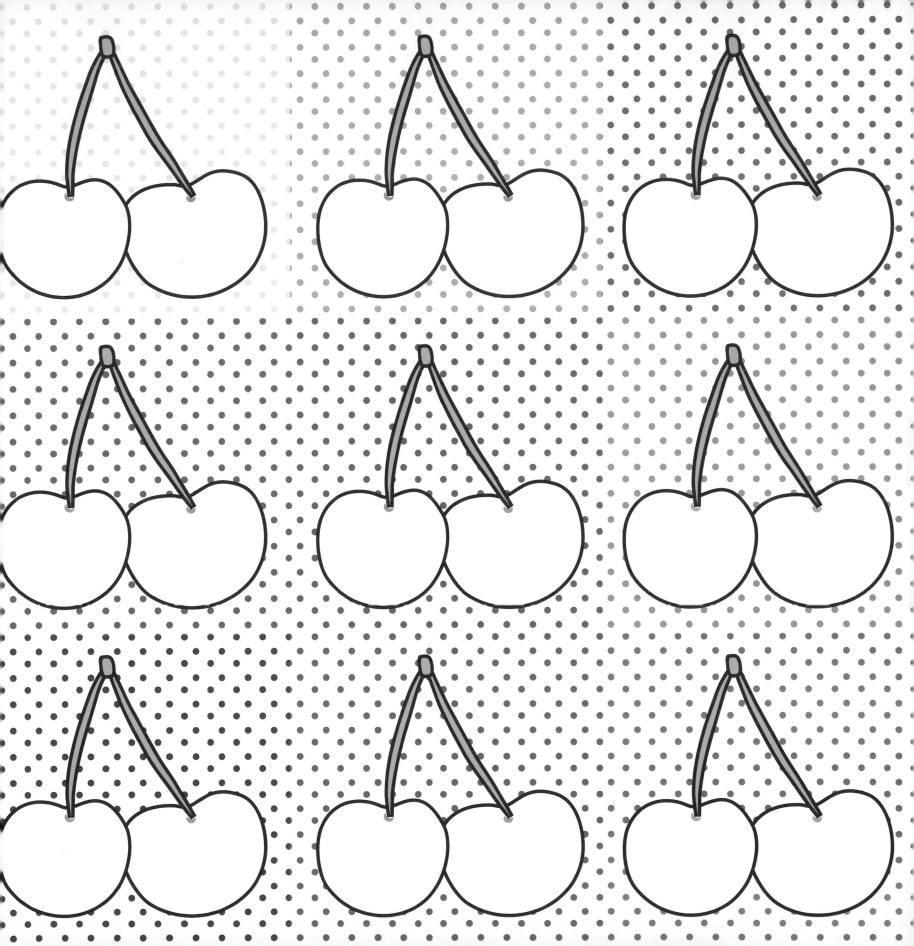

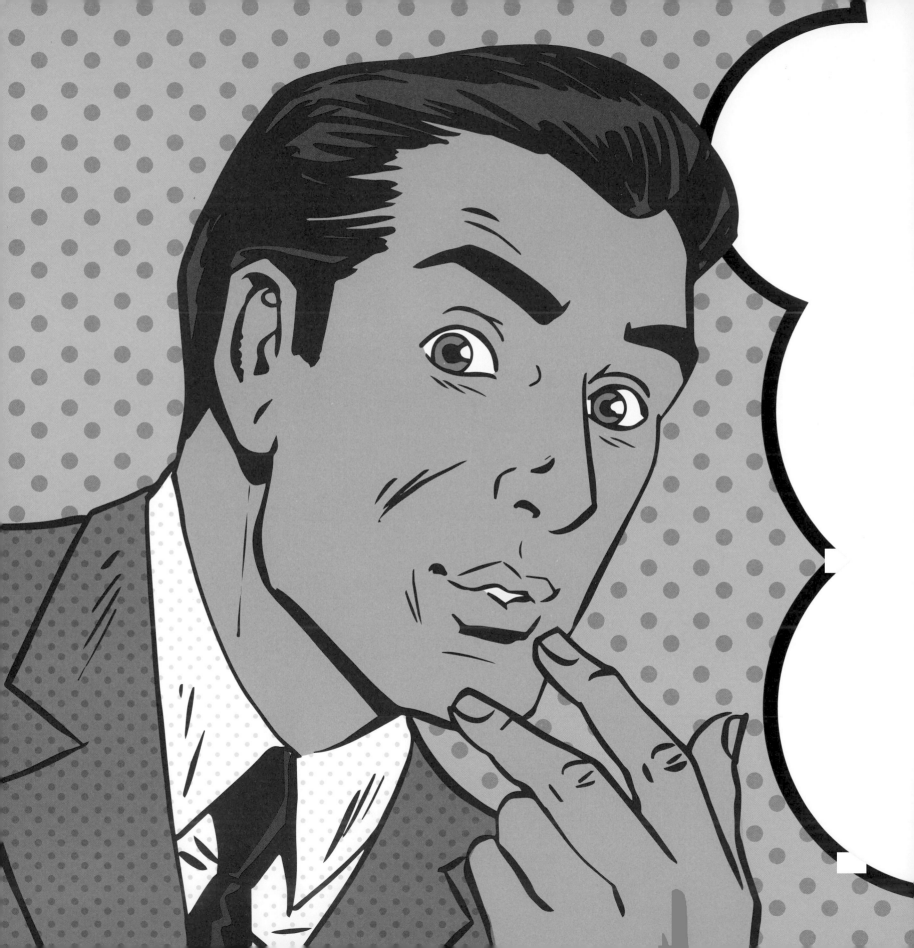

HEY THERE, CUTIE!
DRAW WHAT OR WHO HAS CAUGHT THIS GUY'S EYE.

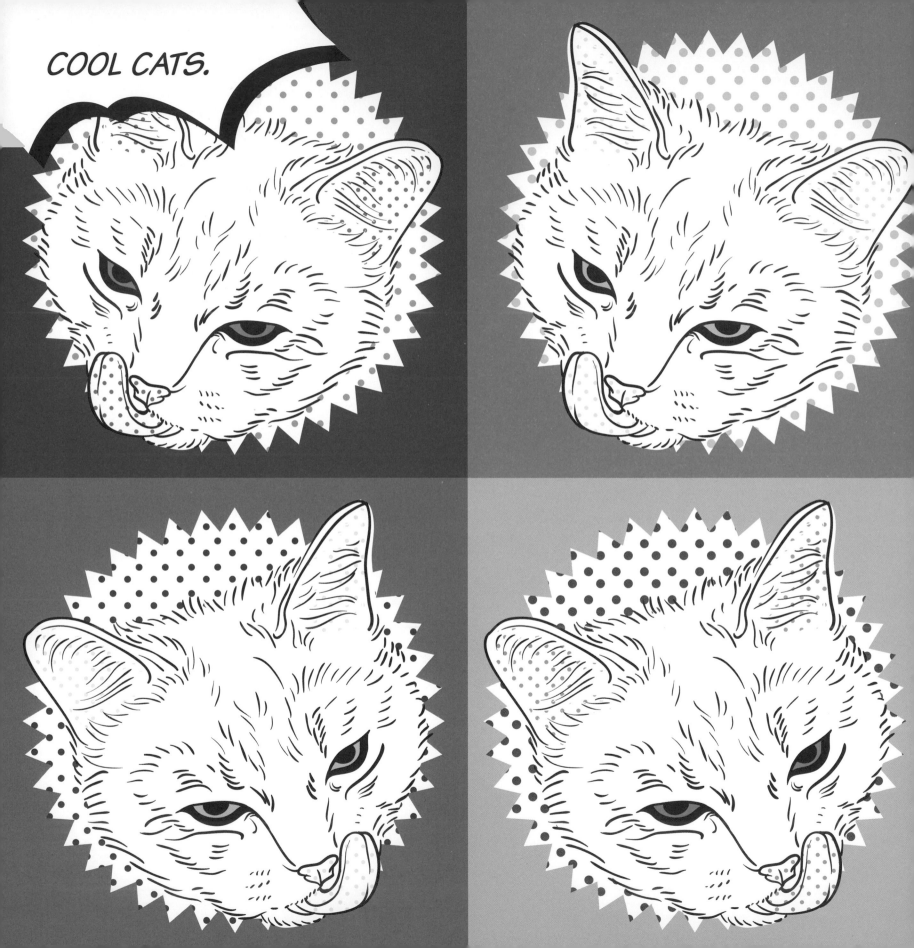

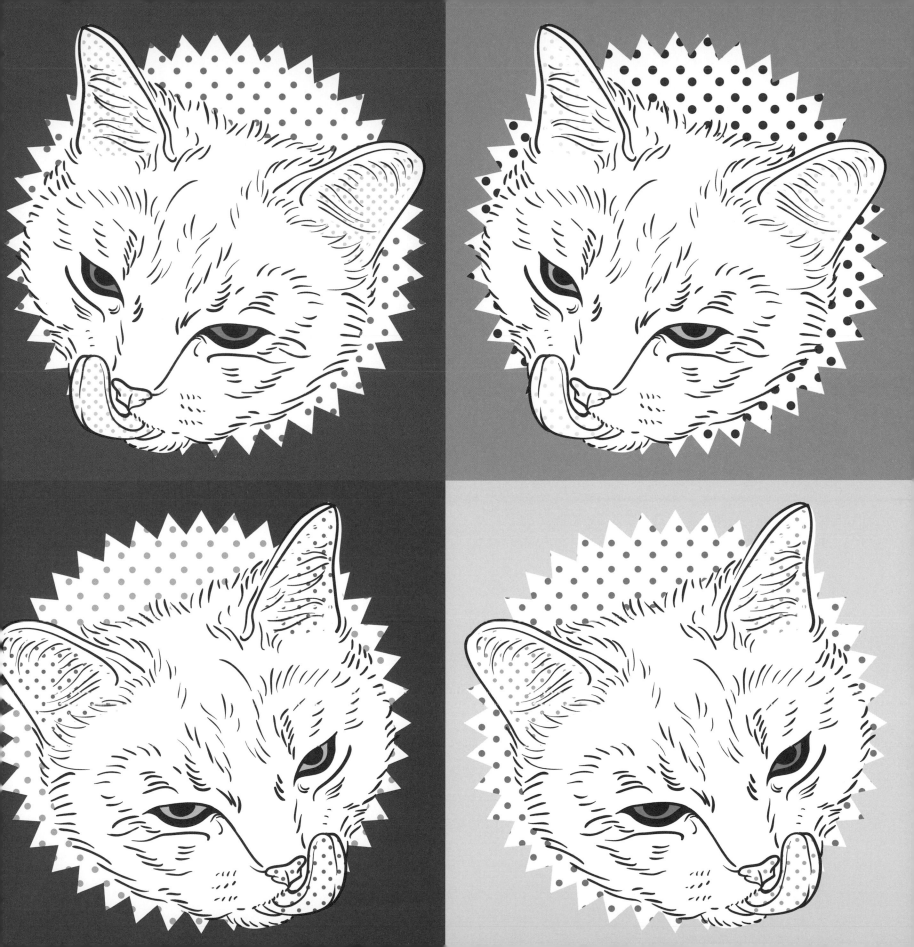

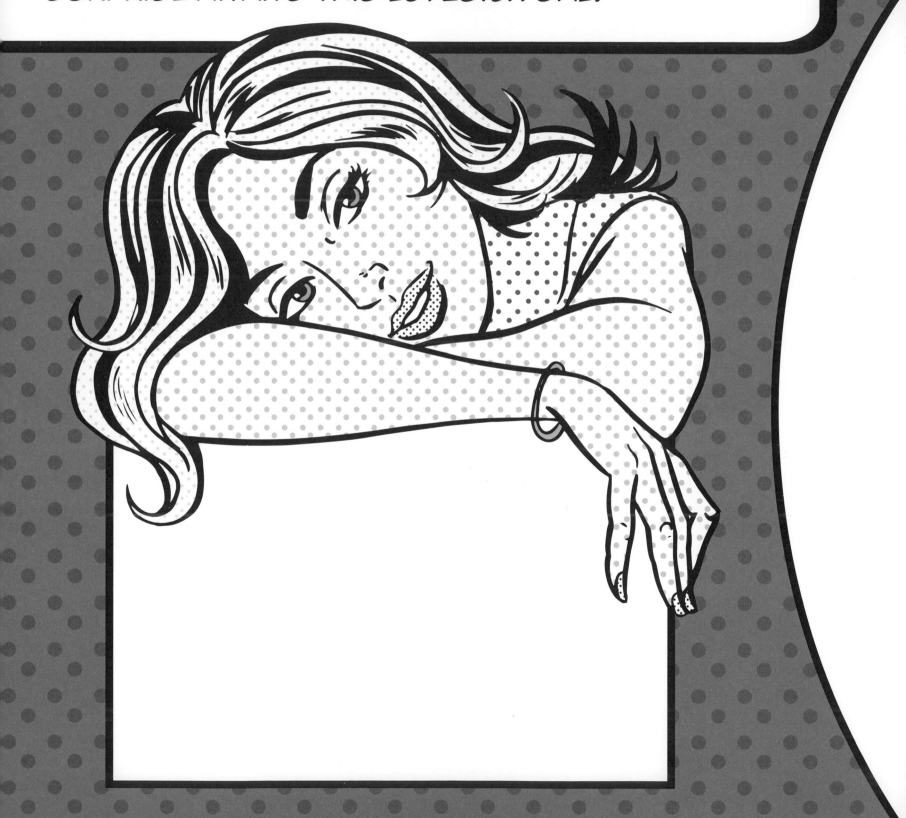

PRINCE CHARMING HAS ARRIVED!

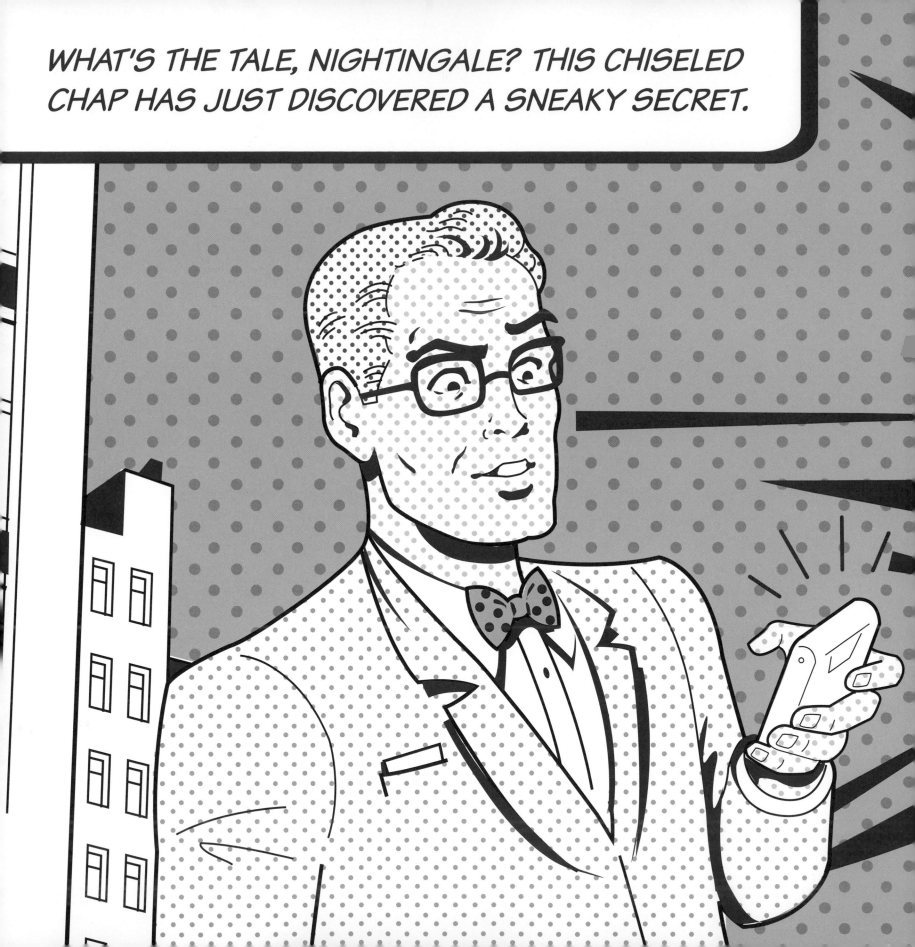

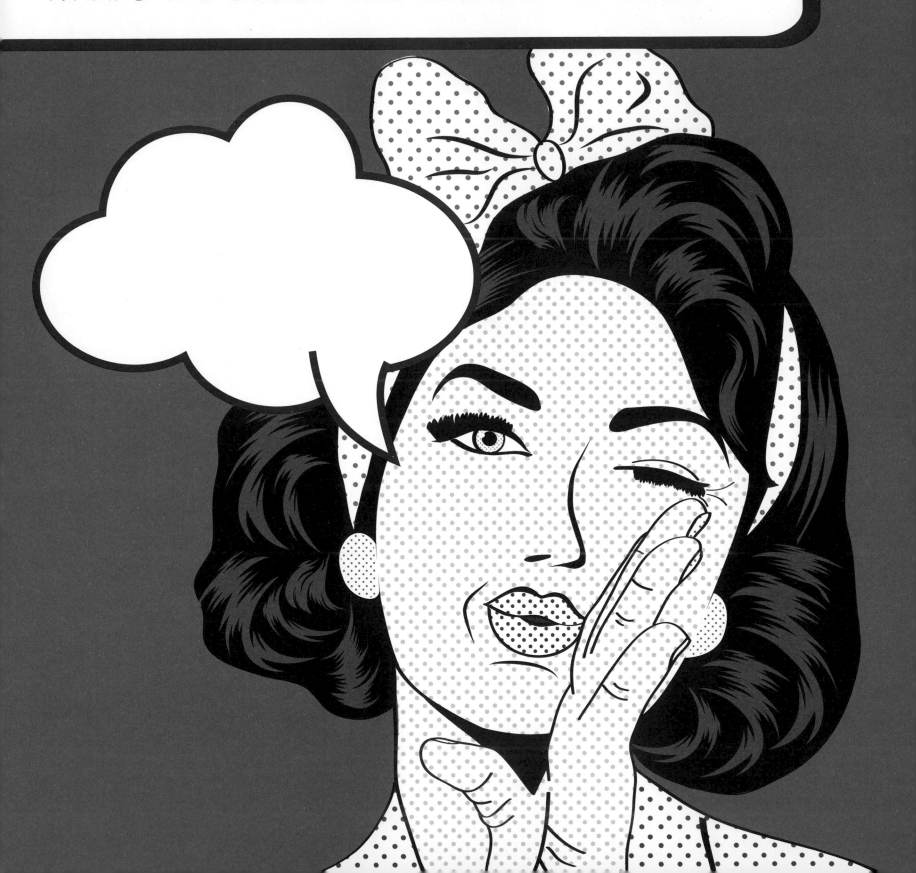